North Shore

IMAGES FROM O'AHU'S FAMOUS COASTLINE

Photography by
Adam A. Palmer

Mutual Publishing

This is an abridged version of *North Shore*
All photographs © Adam A. Palmer

ISBN-10: 1-56647-995-9
ISBN-13: 978-1-56647-995-0
Library of Congress Control Number: 2013933790

First Printing, May 2013
Second Printing, January 2018

Mutual Publishing, LLC
1215 Center Street, Suite 210
Honolulu, Hawai'i 96816
Ph: 808-732-1709 / Fax: 808-734-4094
Email: info@mutualpublishing.com
www.mutualpublishing.com

Printed in China

Introduction

Have you craved a chance to jump from a peak into the ocean below? Then make sure to join other thrill-seekers at the jumping rock in Waimea Bay. Perhaps you want to see the legendary surfing sites most only encounter through their televisions – places with perfect tropical names and killer waves like Banzai Pipeline and Sunset Beach. You can trek through lush flowers and other vegetation to inland waterfalls or spend your time snorkeling the reefs of Shark's Cove and Laniākea (a.k.a. Turtle Beach), where you will encounter honu and other unique underwater occupants by the droves. Take a break and find a shrimp truck or shave-ice stand with flavors guaranteed to taste better than anything else you've had during your stay. When the sun begins to sink into the ocean, any North Shore beach will offer an amazing front-row seat for a true postcard sunset. But the fun doesn't end when the sun goes down – there's nightlife, restaurants and more to entertain sun-drenched visitors and locals alike in surf towns like Hale'iwa.

Big-wave surfing is the North Shore's main draw with the most well-known surfers in the world showing up each year to try their hand once again at some of the best and toughest waves on the planet. However, even when tourist season is at its peak or a highly touted surfing competition brings out the best-of-the-best and their fans, the North Shore still maintains a relaxed, almost sleepy atmosphere. For anyone simply meandering along Kamehameha Highway there are little gems to be found around each turn, such as weekly farmers markets and produce stands or a variety of local shops, some with an amazing array of beach attire and others with a more eclectic inventory.

This is O'ahu's world-renowned North Shore, a pristine stretch of sand and surf, full of laidback charm and more famous locations than many other larger, bustling places can claim. Once you visit, you'll instantly know your Hawaiian experience is complete.

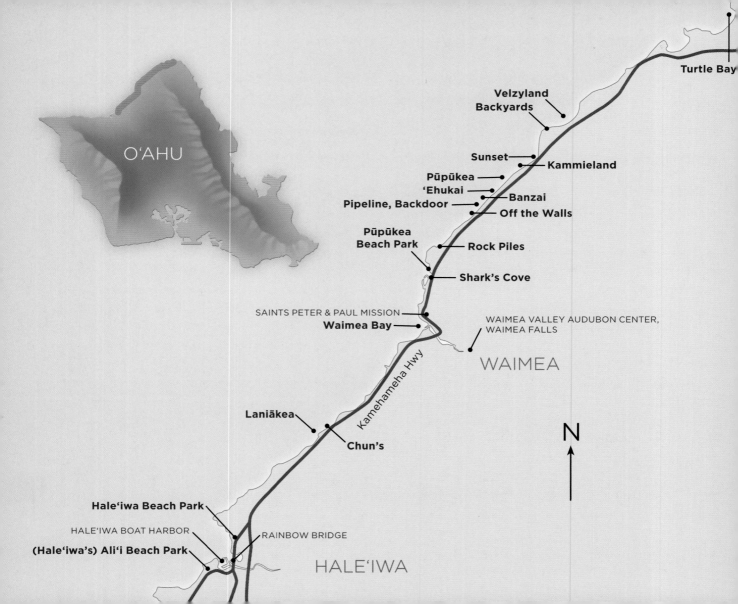

O'AHU

Turtle Bay

Velzyland
Backyards

Sunset
Kammieland

Pūpūkea
'Ehukai
Banzai
Pipeline, Backdoor
Off the Walls

Pūpūkea
Beach Park
Rock Piles

Shark's Cove

SAINTS PETER & PAUL MISSION
Waimea Bay

WAIMEA VALLEY AUDUBON CENTER,
WAIMEA FALLS

WAIMEA

Kamehameha Hwy

Laniākea

Chun's

N

Hale'iwa Beach Park

HALE'IWA BOAT HARBOR
RAINBOW BRIDGE
(Hale'iwa's) Ali'i Beach Park

HALE'IWA

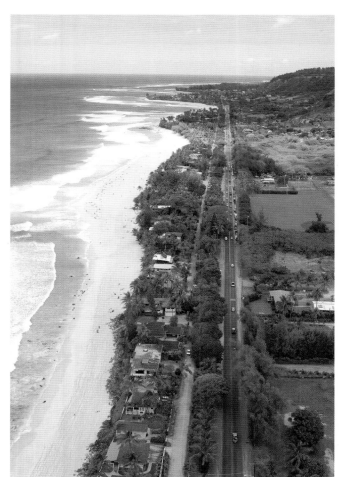

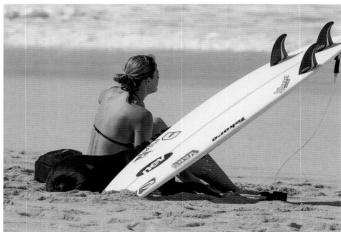

'Ehukai Beach Park, located at 59-337 Ke Nui Road, is actually tucked away out of sight of Kamehameha highway, the North Shore's major thoroughfare. In the vicinity, surf shops and surfboards are as plentiful as the waves that roll in along this stretch of coastline as well as exquisite restaurants like Banzai Sushi.

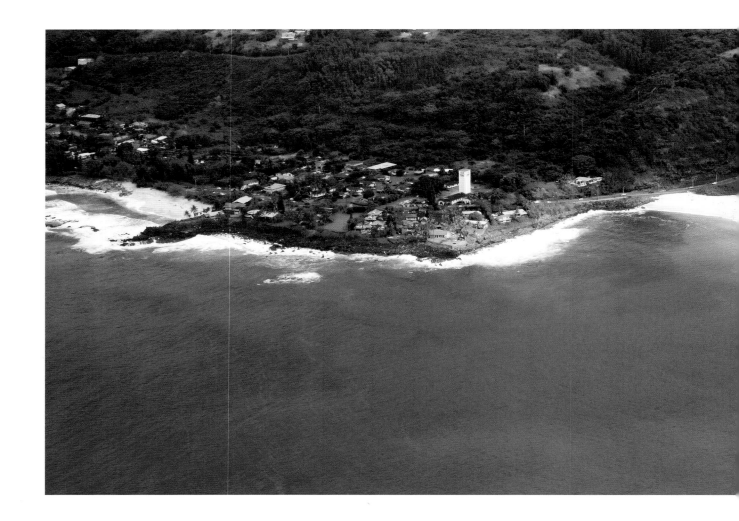

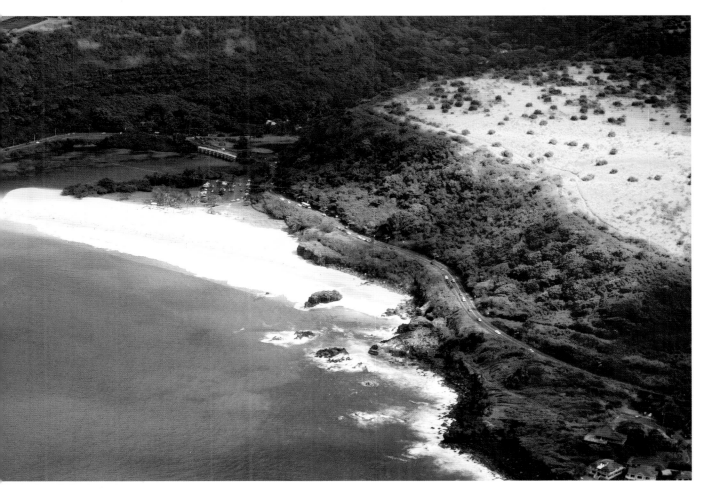

An aerial view of the North Shore at Waimea Bay. For the thousands of first-time visitors to this surf mecca, the bay serves as an introduction to the North Shore's mythic breaks. Waves can reach 25 to 30 feet during the winter months and should only be attempted by experienced surfers as the treacherous shore break has a history of causing injuries.

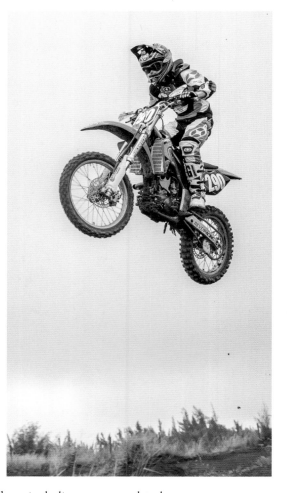

There are plenty of sights and sounds along the North Shore including some unrelated to the beach. At the Kahuku Motocross Track bikes fly in all directions at speeds reaching 60 mph.

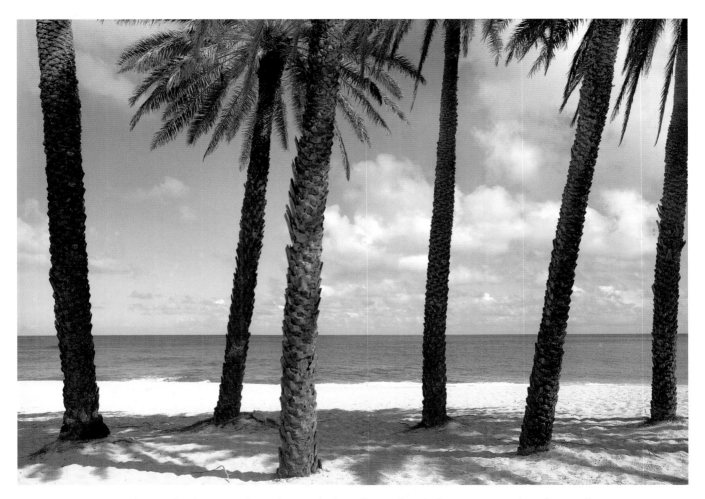

A cluster of palms provides welcome shade at Sunset Beach, home to several professional surfing contests including the Gidget Pro and O'Neil World Cup, contests that are part of the Van's Triple Crown of Surfing Contest. Sunset's winter waves are some of the North Shore's most treacherous.

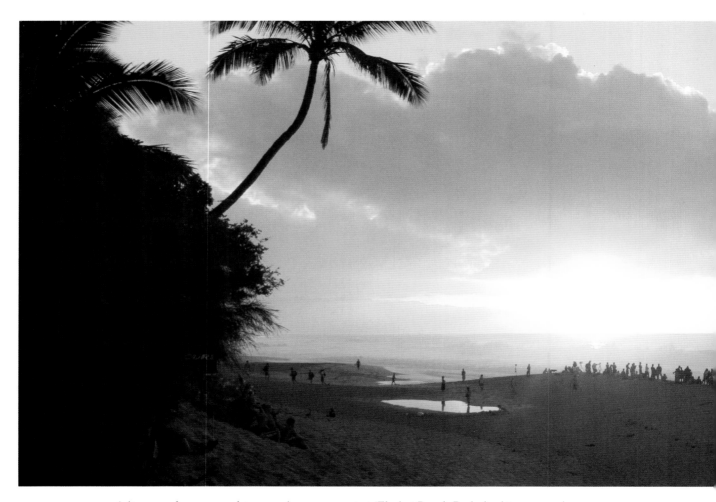

A line up of wave worshippers observe sunset at ʻEhukai Beach Park, looking toward the legendary Pipeline. The acre size beach park, that can only be spotted from Kamehameha Highway, is one of the best vantage points to watch the action at Pipeline.

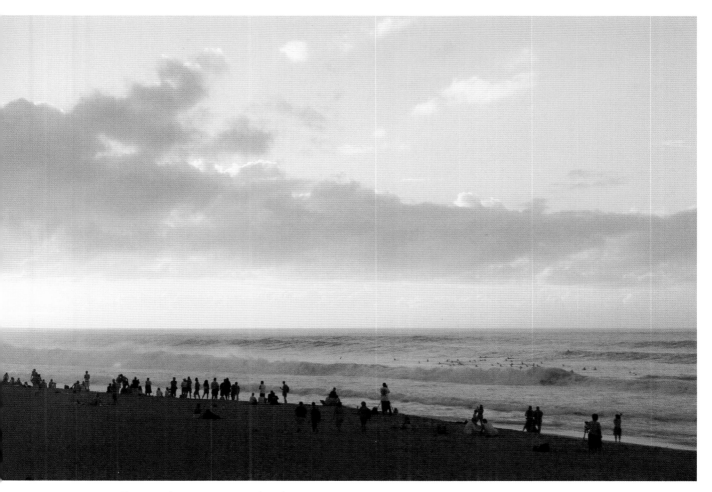

During the summer months, there are easier water pursuits such as snorkeling and swimming, but otherwise, this beach is best known for its rough-and-tumble surf. The shallow reef regularly causes injuries so the beach is always patrolled by lifeguards.

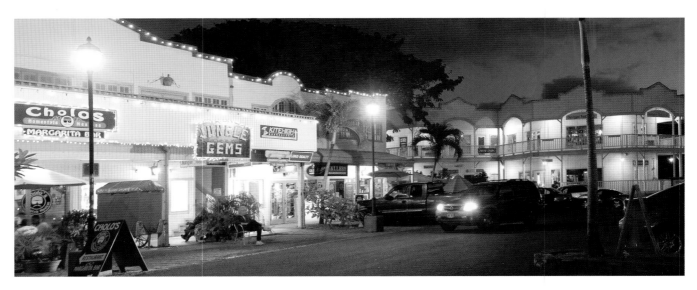

As the day wears on, the North Shore Market Place takes on many different moods. Evenings are a great time to kick back and relax at one of the restaurants or bars, such as Cholo's.

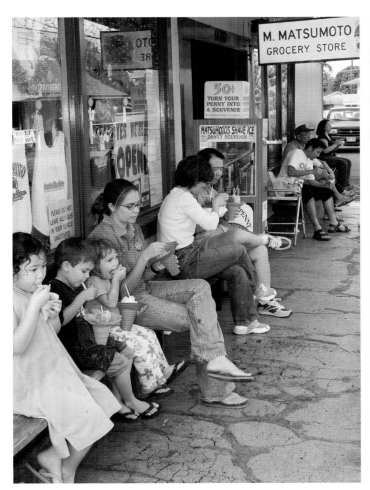

A common Hale'iwa sight – visitors lining the walkway in front of Matsumoto Shave Ice.
At right, the focus of their attention: a rainbow shave ice fit for a sunny North Shore day.

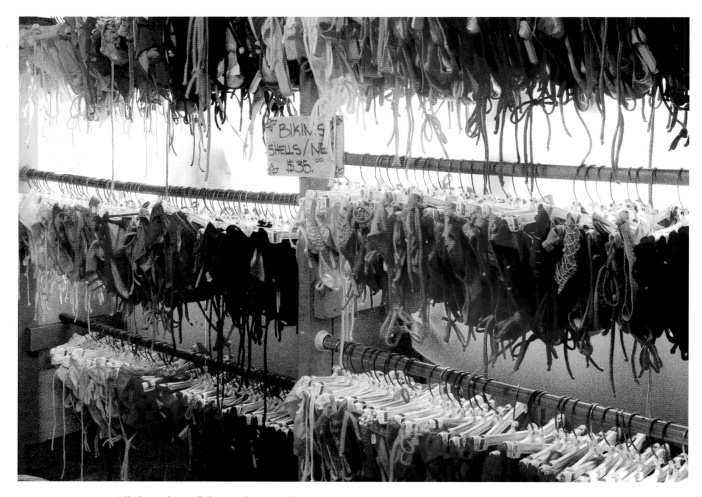

All the colors of the rainbow, and maybe some that aren't, are on this rack of itsy-bitsy bikinis. Shops in Hale'iwa are full of beachwear and other accessories perfect for a day at one of the many North Shore beaches.

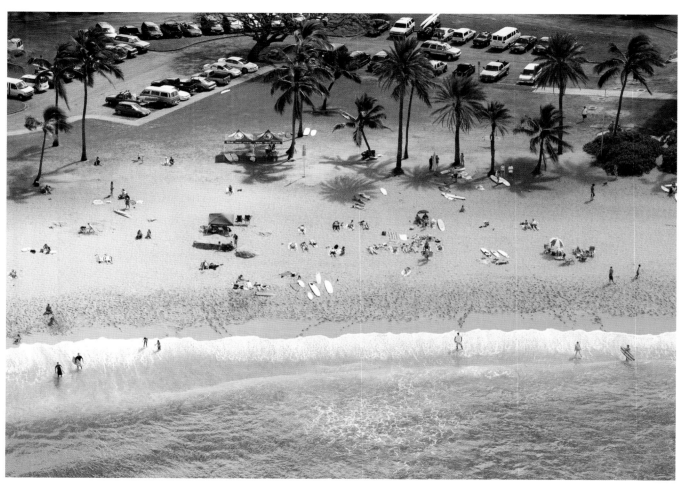

A bird's eye view of sunbathers soaking up the seeming perpetual sunshine at Ali'i Beach Park, located just to the west of the boat harbor. The beach park is best known for its surfing waves along the dangerous break known simply as "Hale'iwa" and hosts competitions like the Hawaiian Reef Pro and Women's Triple Crown of Surfing events.

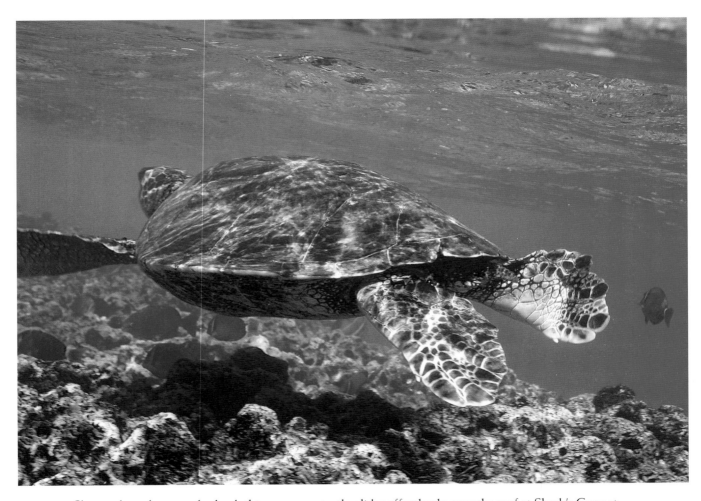

Slow and cumbersome by land, this green sea turtle glides effortlessly over the reef at Shark's Cove at Pūpūkea. Shark's Cove is frequented by these turtles as well as many other sea creatures, and is a popular snorkeling and diving location in the summer months. There are also underwater caves, including a popular spot for divers called the "Elevator Shaft" that drops fifteen feet down through the reef.

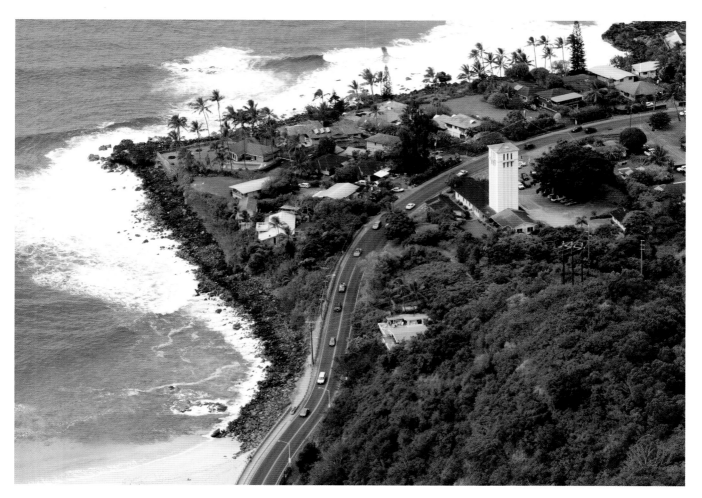

The campanile of the Saint Peter and Paul Catholic Church, in the center of this overhead view, is the familiar landmark signaling visitors and locals alike that they have reached Waimea Bay. The church is actually the remnant of an old rock-crushing plant, the Waimea Rock Quarry, that was abandoned once the section of Kamehameha Highway from Waimea to Kahuku was completed.

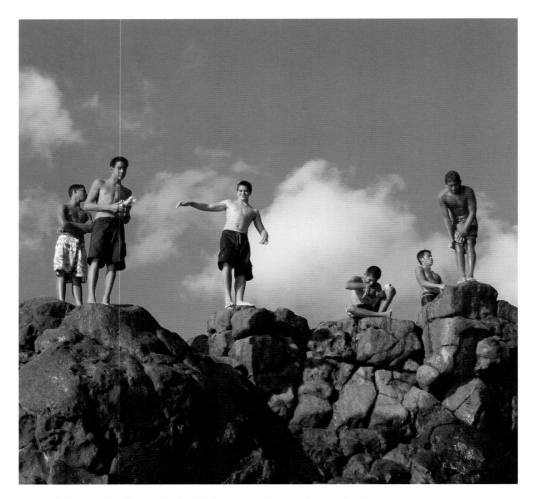

Local divers take flight off the Waimea jumping rock, which also has an underwater tunnel beneath it. On any given day while driving down Kamehameha Highway, motorists can see people clinging to the rock like barnacles, waiting for their turn.

Buoyed by the popularity of movies and television shows depicting women big-wave riders, the number of females flocking to the North Shore – and enjoying the surfing – has skyrocketed in recent years.

Visitors enjoy a leisurely moment beside the calm summertime waters at Waimea Bay. Swimmers sometimes mistake the summer's easy surf as an indicator of what it's like year round, but Waimea Bay can be dangerous, which is why lifeguards are stationed

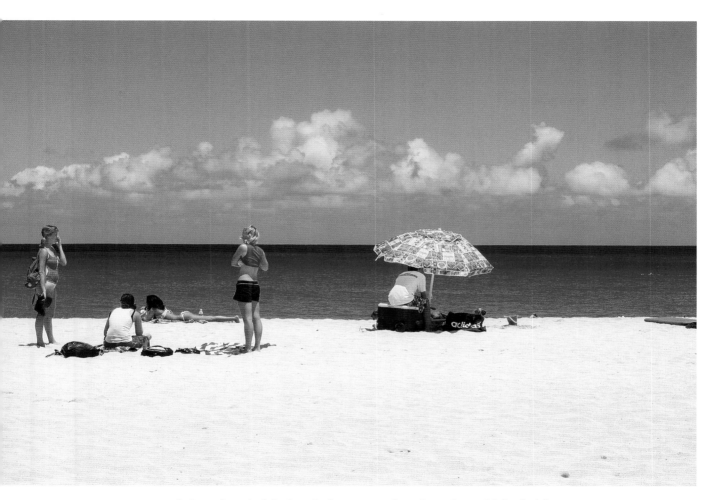

year round. At each end of the beach there are reefs with turtles and fish ideal for snorkeling during the summer months.

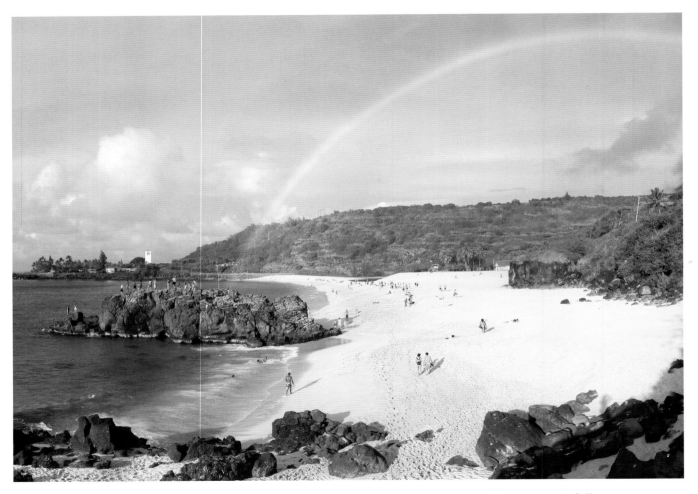

Hawai'i is famous for its rainbows, and the North Shore is no exception. Here, a superb full rainbow briefly graces the setting at Waimea Bay, appearing to end at the jumping rock. Waimea means "reddish water" – the area earned the name due to the heavy rains that force muddy water from the river into the bay.

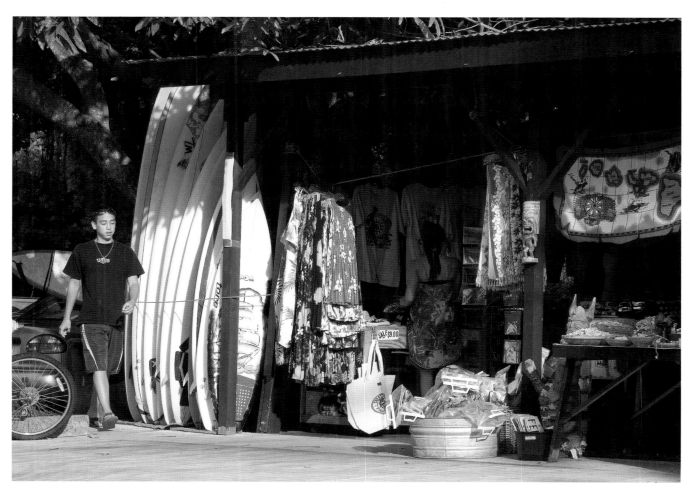

A small and shady surf shop is the first sign of commerce that greets eastbound foot travelers crossing over Rainbow Bridge into Haleʻiwa. The narrow bridge was built in 1921 and has shops and rentals on either side.

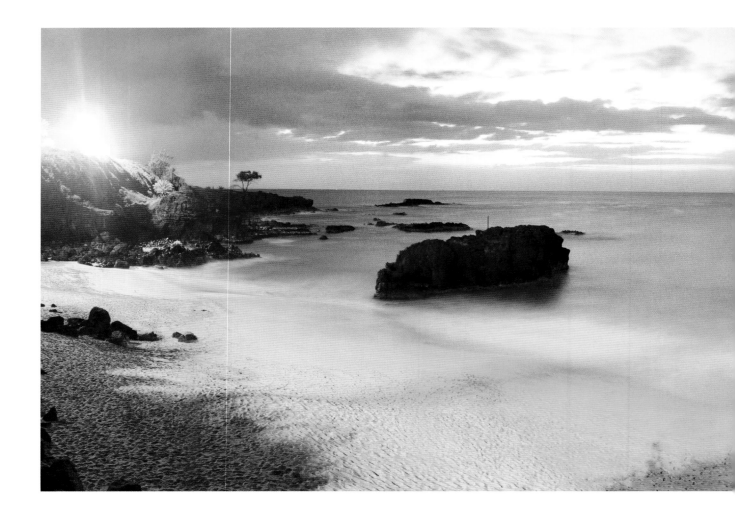

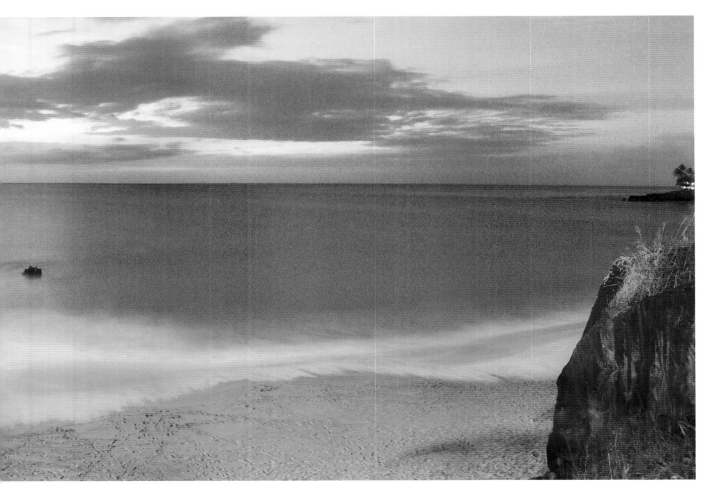

After the sun goes down, Waimea Bay takes on a surreal presence particularly when there is a full moon. Waimea was the first place on Oʻahu that Westerners made contact with Hawaiians in the late 1700s. It was also a popular burial site and even had a "haunted house."

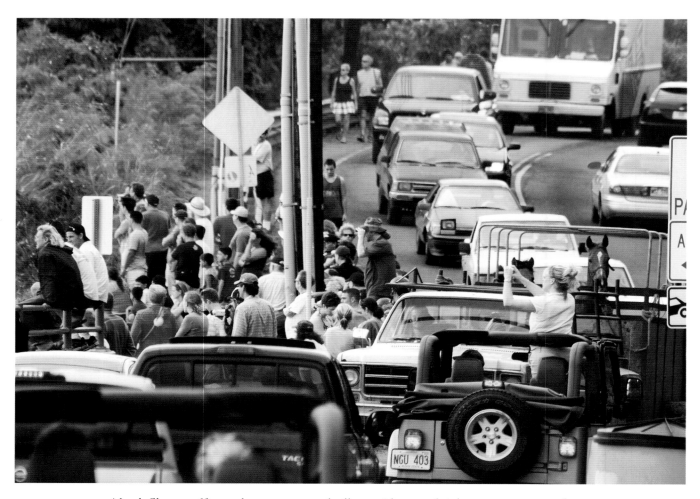

North Shore traffic snarls to a near standstill as residents and sightseers stop to watch the Quicksilver/Eddie Aikau Memorial Big Wave Classic surf meet, one of two dozen winter months North Shore contests.

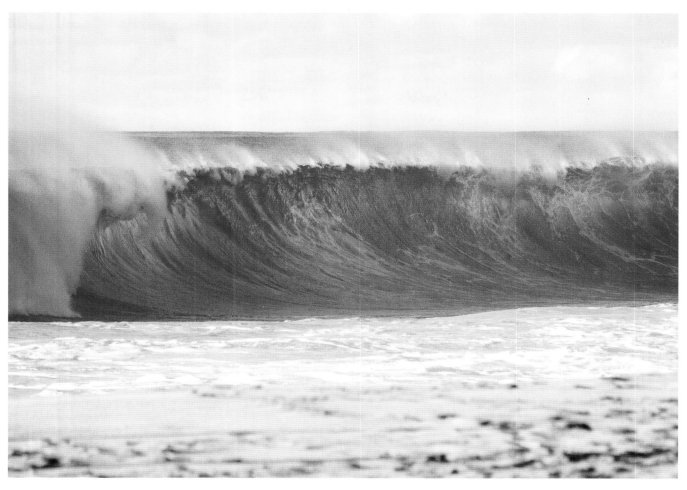

An unridden big wave crashes near the shore at one of the North Shore's many surf breaks – this one is known as Off the Walls, located on the northern side of Banzai Rock Beach Support Park, which sits at the eastern end of Ka Waena Road. To the south is Log Cabins, another popular – and treacherous – break.

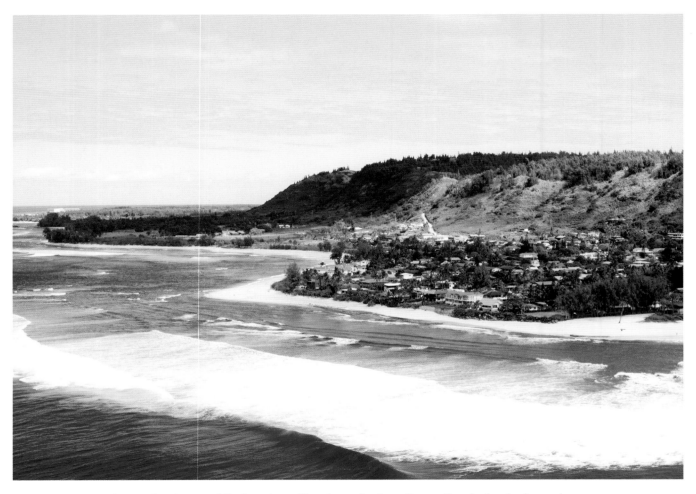

An overhead view of Backyards surf break not far from Sunset Beach clearly shows the big waves rolling in. Sights like this one are not uncommon during the winter months. During the summer, this stretch of beach and surf is popular for windsurfing, kayaking, paddle boarding and swimming.

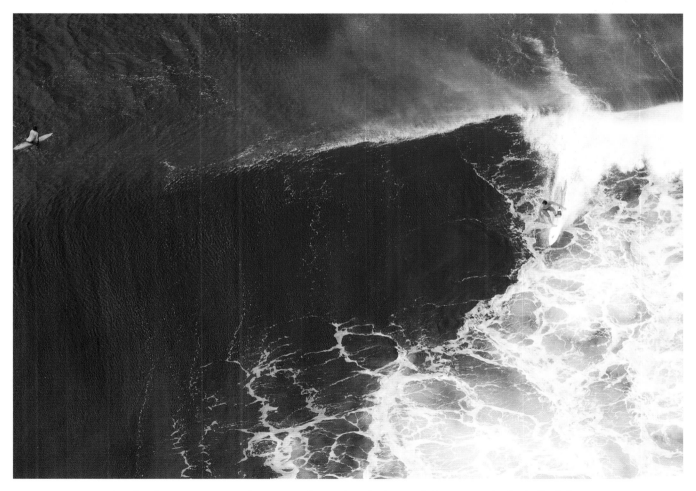

A rider drops in on a gnarly wave at Sunset Beach, famously known as the kickoff of the Triple Crown of Surfing contest. In early December, the world's best surfers make their way to this stretch of shoreline.

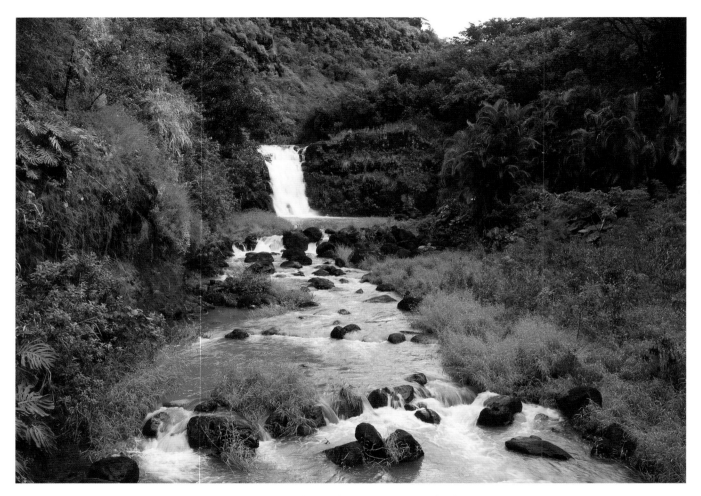

Waimea Falls, a popular natural wonder, overflows after heavy rains. The falls at one time were known as "Waihi," or "dripping water," because even when there wasn't rain or the river above was low, a small amount of water still dribbled through the falls. In addition to the falls, the valley hosts an abundance of native plants and animals.

North Shore housing runs from the rustic to the opulent, although the days of the beachcomber's low-rent oceanfront crash pad is gone. Reservations anywhere should be made far in advance, especially during surfing season.

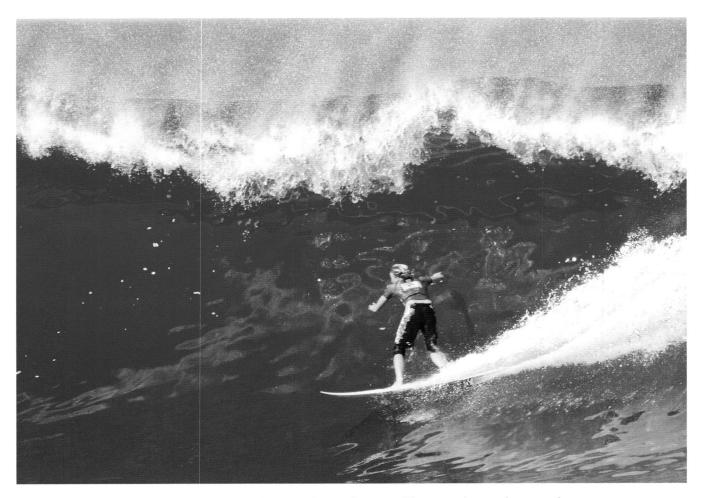

A pro surfer pulls into a barrel at a Pipeline surf contest. This site is known for its perfect barrels during the winter months and being close to shore, it is a great vantage point for spectators. The beach near Pipeline is across from Sunset Elementary School, and, although its parking lot can hold about fifty cars, be prepared to park on the side of the road.

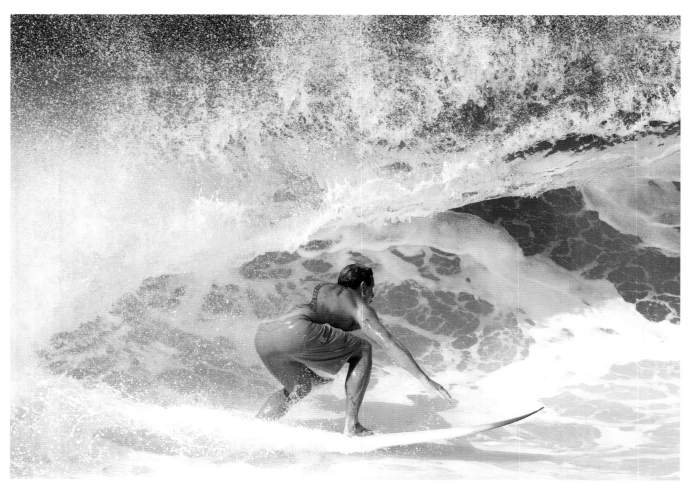

An experienced surfer ducks to get under the heavy lip at Rock Piles, located only a mile from Pipeline. This stretch of water offers great waves for the advanced surfer, and viewers can see the action from the highway although it can be relatively empty on an average day. The best place to park is on the right at the lot by Off the Walls.

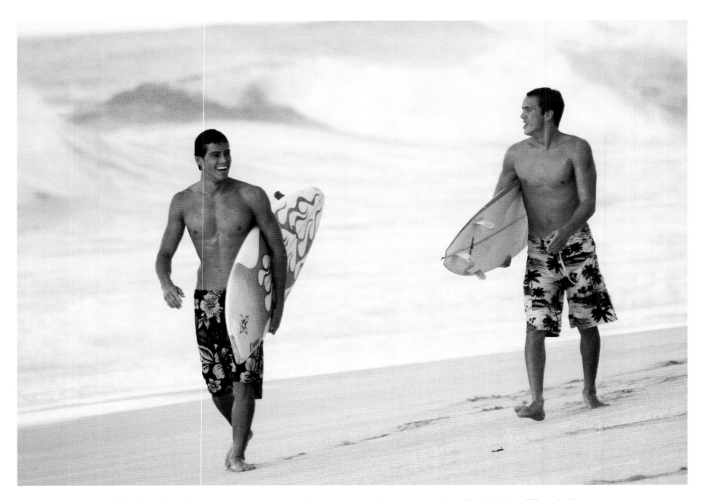

Two local surfers compare notes as they come in from a round at Rock Piles. The shallow reef provides a challenging break, not something for the faint of heart.

Although North Shore surfing has traditionally been dominated by men, more and more women are ready to take on the famous big waves, such as those found at Rock Piles near the Banzai Pipeline.

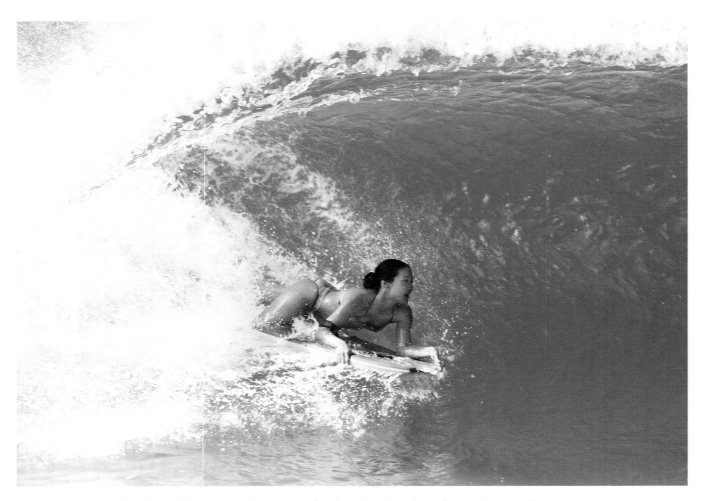

A female bodyboarder pulls into a perfect barrel with style and ease. More and more women are taking to the big waves that pound the North Shore beaches, and more guys are willing to let them. In recent years, top women surfers have taken their participation to a new level in events like the Sea Hawai'i Pipeline Women's Pro on O'ahu.

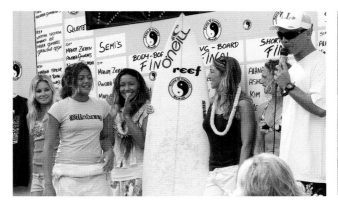

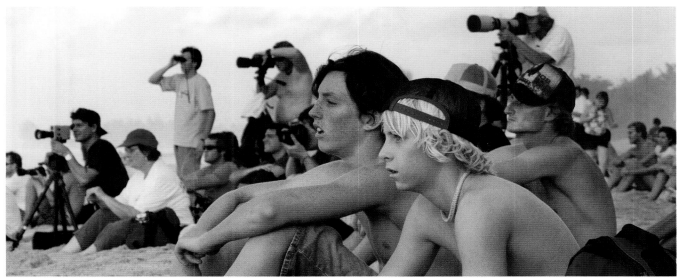

In the winter months, the North Shore frequently turns into a media circus as giant waves bring surf contests and spectators to town. Pipeline, at 'Ehukai Beach Park, hosts the Billabong Pipeline Masters surf contest in mid-December each year.

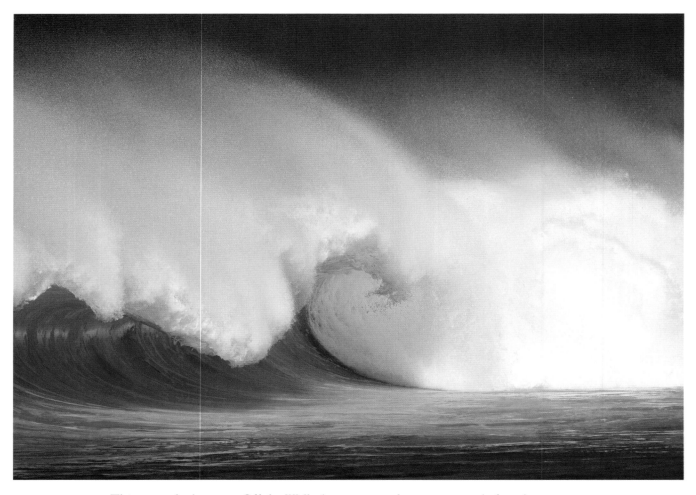

This untouched wave at Off the Walls demonstrates the awesome and often dangerous power of the North Shore's waves between November and February each year. Next to Off the Walls is its neighbor, Backdoors, an equally demanding surf site.

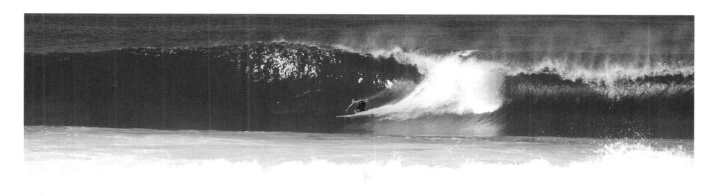

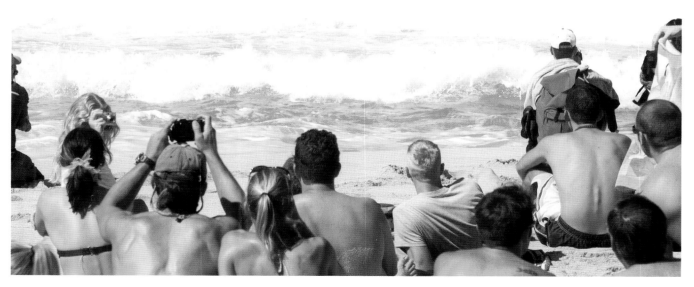

A classic surf scene captured during the Billabong Pipe Masters competition, one of the most famous of the annual North Shore contests. It is the grand finale of the Van's Triple Crown of Surfing event, as well as the last event for the Association of Surfing Professionals Men's World Tour, with some of the best and most dangerous waves in the world, because of the number of lives it has claimed.

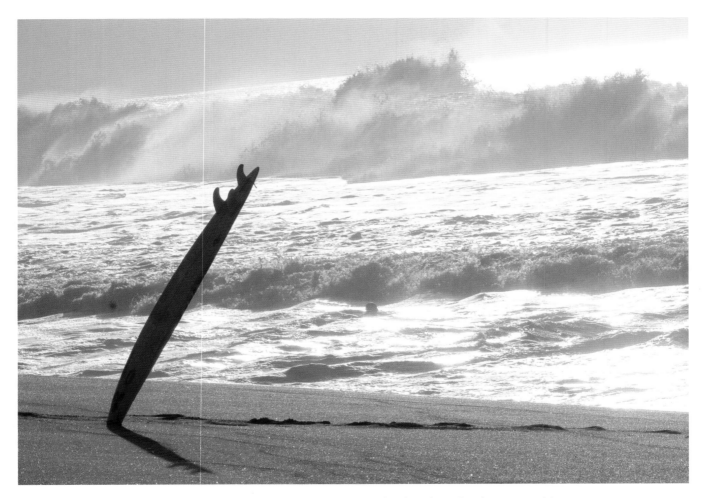

A solitary surfboard is silhouetted against a cascade of crashing Pipeline waves. It's rare to see a surfboard on the beach without its owner when sets are consistent. The right board can make all the difference and surfers have their preferences, whether it's a long or short board, tow-in, gun or hybrid.

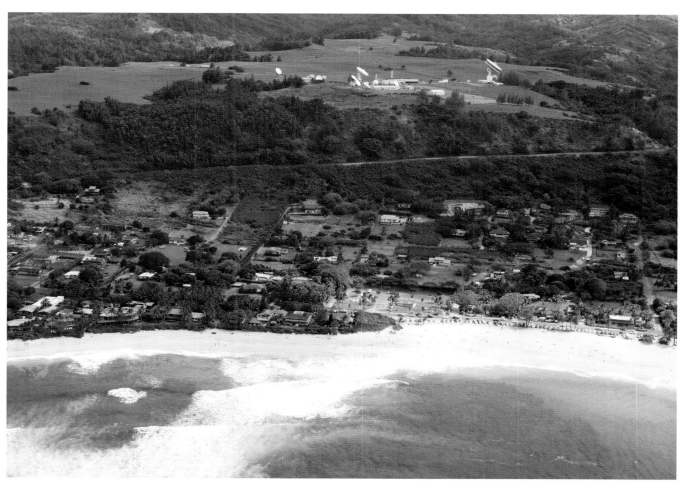

This aerial shot of Sunset Beach highlights the eastern portion of the narrow seven-mile strip of North Shore landscape that's famous as the surfing mecca of the world. The rolling waves are easy to spot, charging to the beach that has some of the finest white sand on O'ahu. The Sunset surf spot that's so well-known is located on the eastern end of the beach and jump starts the Triple Crown of Surfing contest each year.

41

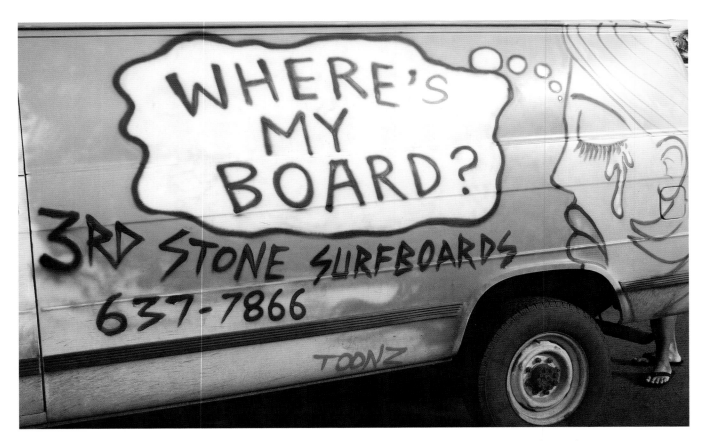

Custom paint jobs – occasionally unsponsored overnight surprises – have transformed a number of North Shore vehicles into billboards and mobile works of art. Just visit "Art..is" in the North Shore Market Place to see for yourself.

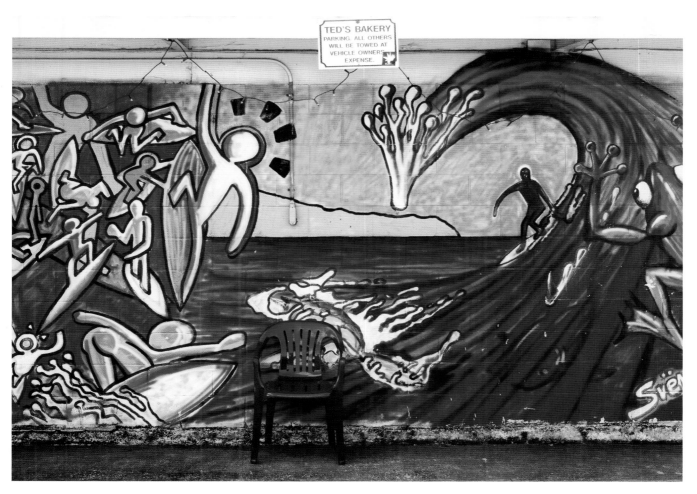

This mural on the side of locally popular Ted's Bakery, next to Kamehameha Highway in Sunset Beach, is another example of distinct North Shore art. Obviously, surfing is the mural's main theme.

For some, a nap at Shark's Cove is as close as the nearest patch of pillowy North Shore sand. If you're in a need of a pick-me-up, however, head to the Coffee Gallery at the North Shore Market Place.

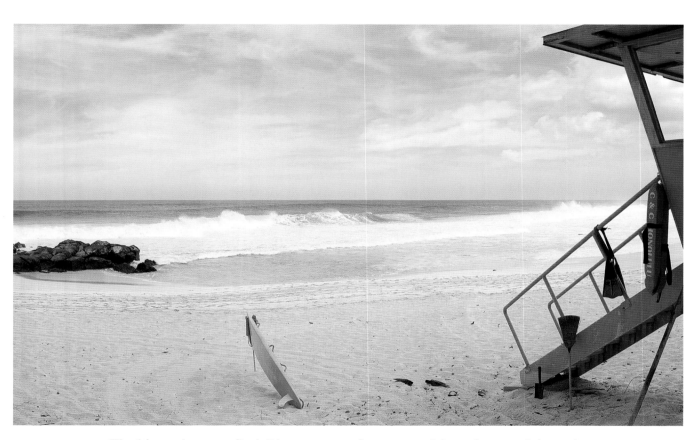

This lifeguard tower at Rock Piles is just one of many up and down the coast. Lifeguards stay busy, especially during the winter months when surfers and unsuspecting swimmers meet their match in the water.

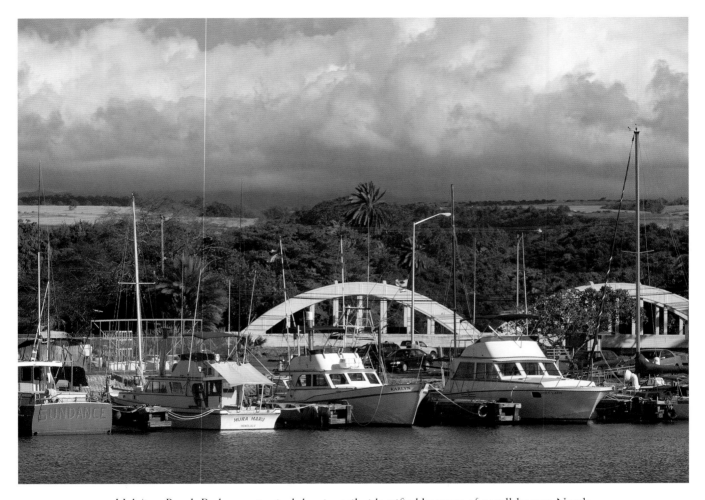

Haleʻiwa Beach Park, on a typical day, is easily identified because of a well-known North Shore icon seen in the background: the Anahulu Stream Bridge, built in 1921, and known to most as Rainbow Bridge.

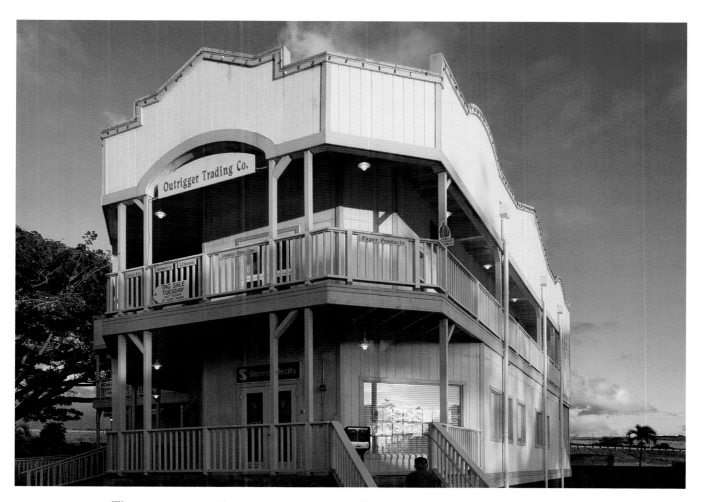

This two-story wood structure, reminiscent of Hawai'i's plantation era and identified only by the Outrigger Trading Co. sign makes for an imposing attraction at Hale'iwa's North Shore Market Place in the late afternoon sun.

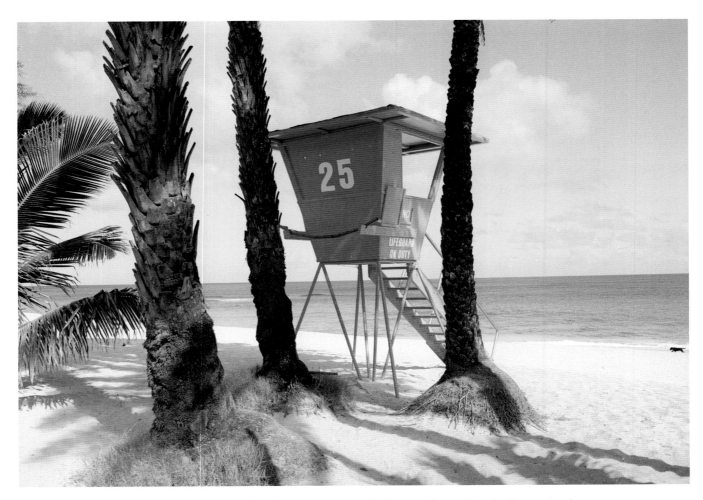

Lifeguards have some of the best seats, especially those at Sunset Beach. On a calm day like this one, they have to be particularly alert thanks to the tricky currents that still run along the beaches.

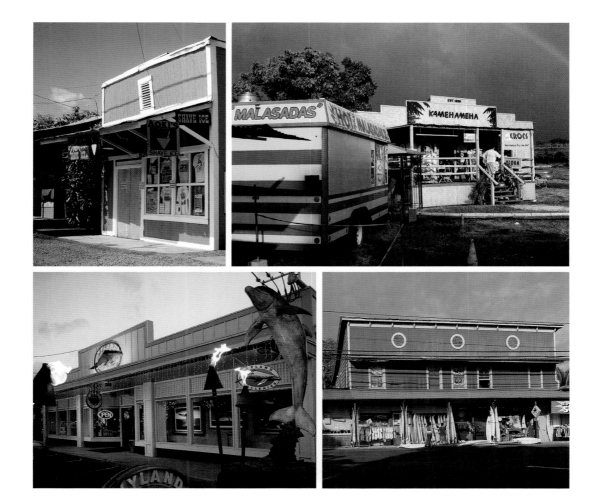

Hale'iwa's rustic, freewheeling appeal can be seen in the businesses, both new and old, that line the two-lane Kamehameha Highway leading through town. (Clockwise: Aoki's Shave Ice; malasada truck and Kamehameha shirt stand; Surf & Sea, North shore icon and leading surf shop; and Wyland Galleries.)

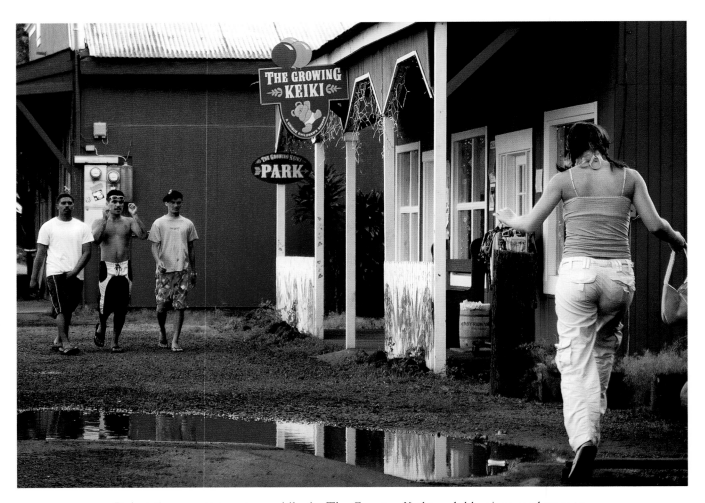

Pedestrians negotiate water puddles by The Growing Keiki, a children's apparel store in Hale'iwa. Unique boutiques and eclectic shops are also popular around this surf town, ranging from affordable to expensive prices.

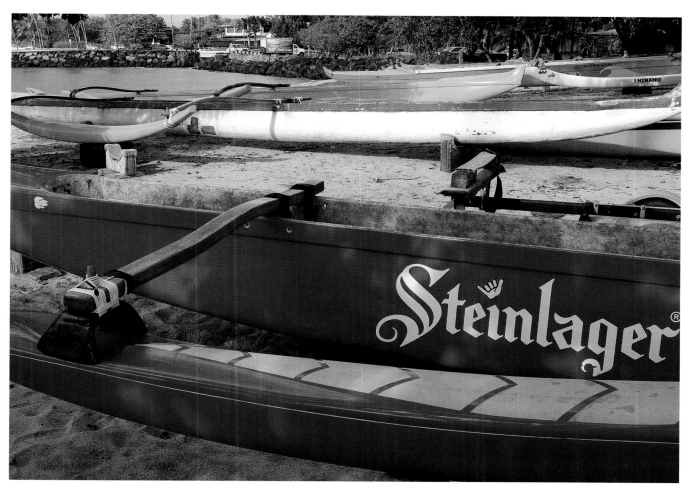

Made in the shade. This outrigger canoe takes a time out from the action waiting idly beside the sea near the Haleʻiwa Boat Harbor. Hitch a ride with a team for a true taste of Hawaiian culture.

A view from the ocean toward the nearly constant daytime flow of vehicles along the Kamehameha Highway hillside overlooking Waimea Bay. Here there is a spectacular and unobstructed vantage point from which to take photographs.

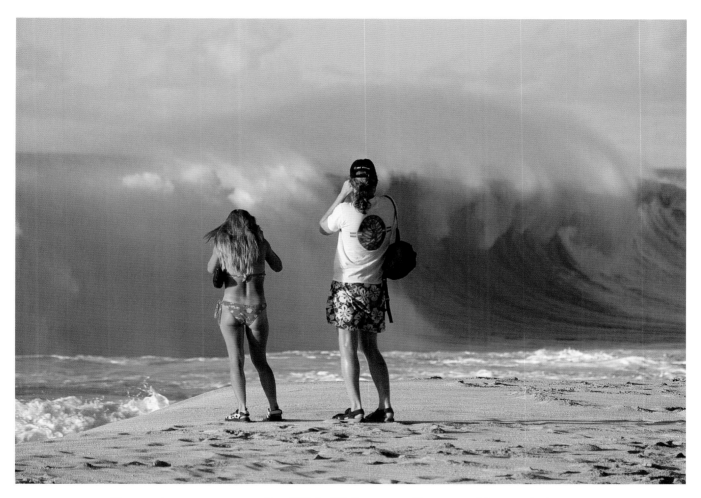

Two tourists capture a pounding Off the Walls wave on film – something to take home as a reminder. Watching the waves can be addicting – it seems like each one is better than the next.

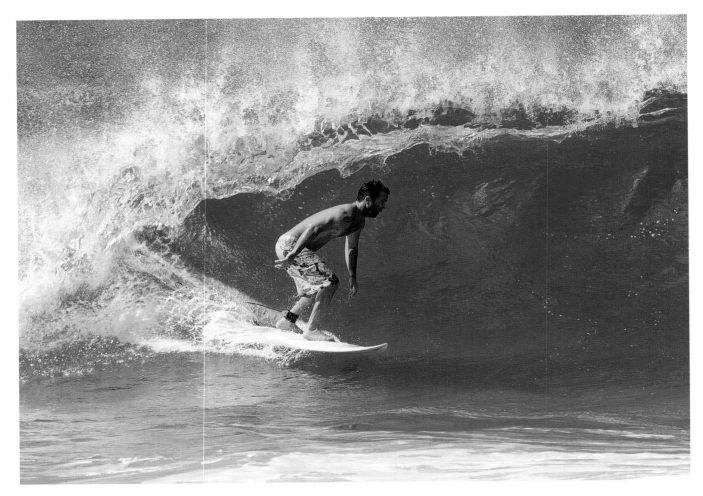

A North Shore surfer pulls into a perfect little barrel at Rock Piles, making it look way too easy to anyone watching from the beach. Rock Piles provides a lot of "practice" with its consistently challenging waves, the result of the dangerous lava rocks and trenches beneath the surface. Rock Piles offers big waves.

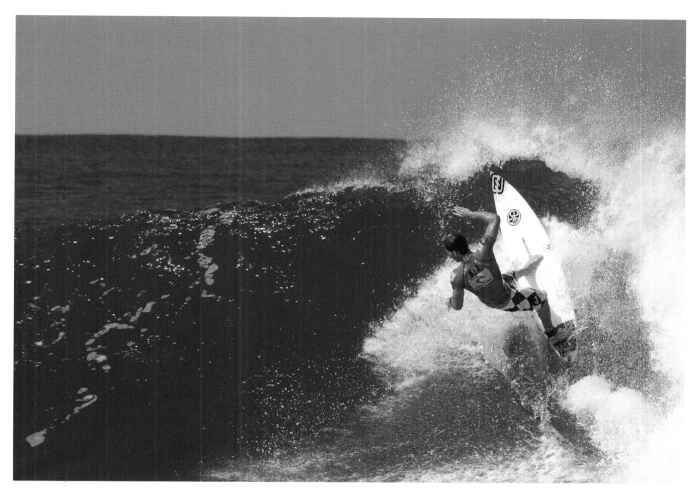

An obviously experienced surfer in control of a North Shore big wave. Just how big a wave remains a matter of debate, since wave measurement is an inexact science and surfers disagree on how best to do it.

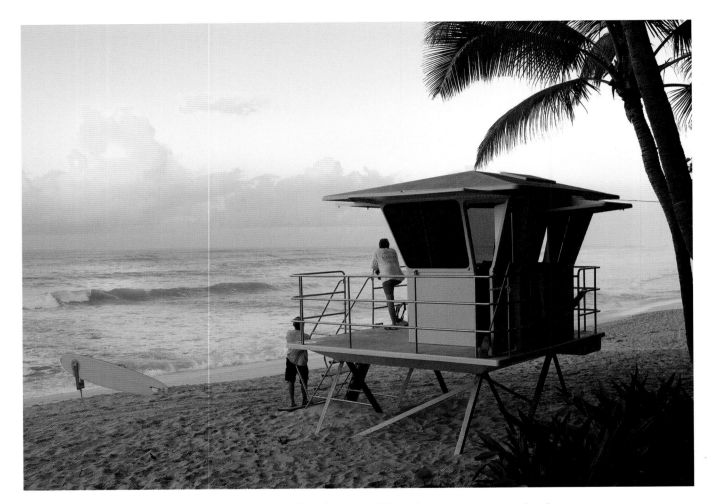

Lifeguard stands are a routine sight at Pipeline, although the once common bright orange, open-air stands have begun to be replaced by newer, more equipped, less colorful models.